W9-ASP-376

RELEASE

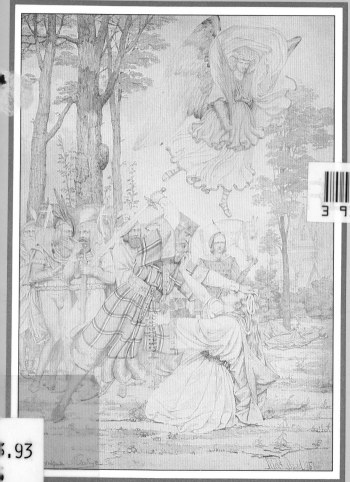

# British Narrative

# Drawings and Watercolors

# 1660-1880

*Twenty-two*
*Examples from*
*The Huntington*
*Collection*

*by Shelley M. Bennett*

THE HUNTINGTON LIBRARY • SAN MARINO, CALIFORNIA

ST. JOSEPH'S UNIVERSITY

3 9353 00227 1698

5.93

British Narrative Drawings and Watercolors 1660-1880

# British Narrative Drawings and Watercolors 1660-1880

*Twenty-two
Examples from
The Huntington
Collection*

*by Shelley M. Bennett*

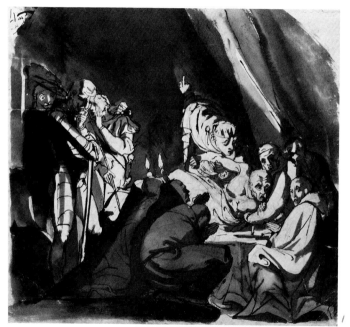

THE HUNTINGTON LIBRARY • SAN MARINO • CALIFORNIA 1985

N
7433.93
.B46
1985

242616

Copyright 1985 • The Huntington Library
Library of Congress No. 85-27262
ISBN 087328-089-X
Publication of this book has been made
possible by a grant from the
California Arts Council

# Table of Contents

# Introduction

The twenty-two drawings and watercolors selected for this catalog reflect the wide variety of narrative art produced in England from the late seventeenth century to the late nineteenth. This representative sampling is from the collection of approximately thirteen thousand British drawings at the Huntington.

A narrative can be broadly defined as a story, a tale which has a beginning, middle, and end. A narrative requires time. The visual and verbal arts differ in the manner in which they create a narrative. The verbal arts are temporal and progressive; thus they can duplicate the sequence in time of a narrative. The visual arts are static and spatial; thus adjustments must be made to convey a story. The choice of moment portrayed visually is critical. It must be a pregnant, meaningful moment which is suggestive of past and future actions. Visual narratives often rely upon a pre-existing knowledge of the story which encourages the spectator to supply the context in which the scene exists. The visual arts also utilize gestures and ex-

pressions that are universally understood to reveal the invisible human passions and thoughts which play an important part in narrative.

The artist has additional means to expand the meaning of a narrative. By exploiting the formal elements of style, for example, the artist can heighten the emotional resonance of a story. But visual narratives invariably invite an accompanying verbal explanation and they need a verbal grounding. Visual and verbal narratives can be interrelated, however, in various ways. One of the most provocative aspects of British art is the variety of different narrative structures developed from the late seventeenth century to the late nineteenth century.

The types of narratives which commanded the greatest attention of British artists during this period were history painting, anecdotal narrative, and book illustration. Visual narratives which deal with heroic actions that reveal moral character are referred to as "history" paintings. These narratives are based on universal ideals which are meant to

1

appeal to the intellect. History painting assumes a large fund of shared literary knowledge.

Anecdotal narratives, on the other hand, focus on incidental, often amusing or touching episodes. By means of imitative description, or closely observed realism, these narratives appeal directly to the viewer's emotions and senses. Anecdotal narratives depict everyday incidents which require no pre-existing literary knowledge to be understood.

The late eighteenth century was the high point in the development of history painting in England, while anecdotal narrative dominated much of the art produced in the nineteenth century. During many earlier periods, however, narrative art was virtually nonexistent in England except in the realm of book illustration which is the continuing, sustaining tradition in British narrative art.

The flowering of history painting in the late eighteenth century in England is linked to the foundation of the Royal Academy in 1768. The exalted aim of the Royal Academy was to train a national school of history painting and by this means raise the status of the artist in English society. Most late eighteenth-century artists, such as James Barry (No. 13), felt that history painting entitled the artist to the greatest public esteem. A related function of the Royal Academy was to provide a public exhibition space for British artists. Through annual exhibitions artists hoped to reach a new audience and market for their narrative art.

History painting was promulgated as the highest category of art by Sir Joshua Reynolds, the first president of the Royal Academy, in the series of lectures or *Discourses* he delivered at the academy from 1769 to 1790. These doctrines, which Reynolds presented to the students of the academy, were to govern academic practice for the next one hundred years. A brief glance at the biographies of the artists represented in this catalog will show how many of the British artists who turned to narrative art had received their initial training in the Royal Academy Schools. Reynolds' *Discourses*, which codified the theories of art

which had dominated academic teaching for over three hundred years, defined the goals of art as truth, beauty, and universality of expression. Only narratives based on hallowed classical literature and heroic historical events from the past could properly stimulate the imagination of the viewer. These universally-known subjects were to be depicted in a single, ideal style which would elevate the mind of the beholder.

Academic theory was modified, however, in artistic practice in the late eighteenth century. New categories of narrative art were developed. There was no one ideal style devoted to the narrow range of lofty narrative themes that prevailed during this period. Instead, the most salient characteristic of the art of the decades around 1800 was the wide range of subjects and styles. Reynolds himself encouraged the development of variety. The artists of this period were concerned not merely with elevating the mind, but also with arousing the emotions of the viewer.

Artists began to explore new sources of narrative in order to express a wider range of experience in art. Some, such as George Romney (No. 10) and William Blake (No. 14), turned to the great English authors, Shakespeare and Milton. Others, such as Benjamin West (No. 7), looked to contemporary, topical events which they imbued with elevated notions of virtue, heroism, and patriotism. There also was a surge of interest in themes which were filled with horror, mystery, and the sublime by artists such as Henry Fuseli (No. 5). Much late eighteenth-century art displays a new interest in exotic, often obscure literature. In some cases, the subjects, such as Philip James De Loutherbourg's banditti (No. 6), of these imaginative scenes have no specific literary source; the spectator must create a story to explain what is depicted. The range of narrative subjects in the late eighteenth century also expanded to include the comic art produced by artists such as Thomas Rowlandson (No. 11) and James Gillray (No. 12).

Late-eighteenth century artists also experimented with a variety of styles in order to heighten the expressive con-

tent of narrative art. The radically reduced linear style developed by artists such as John Flaxman (No. 15) was a particularly effective narrative vehicle. In his line drawings all meaning is concentrated along the edges of the forms and is quickly comprehended. It is a style which seemed to expand the narrative content for a late-eighteenth century audience.

Although history painting was placed at the top of the hierarchy of subject matter in the academy, landscape painting dominated the Royal Academy exhibitions in the late-eighteenth and early-nineteenth centuries. There was a very small buying public for history painting. For this reason the various schemes developed in the years around 1800 to promote English narrative art all came to financial ruin. Boydell's Shakespeare Gallery, Macklin's Poets' Gallery and Bible Gallery, and Bowyer's Historic Gallery included narrative paintings by most artists of the day. They were exhibited for a small admission fee, then engraved and issued as separate prints or book illustrations. None of these ambitious narrative projects, however, found a profitable market in England and, with the collapse of the foreign market for prints during the Napoleonic wars, they all ended in failure.

Attempts at narrative painting in the grand manner did continue in the nineteenth century, but most, such as the scheme for the decoration of the Houses of Parliament, had unimpressive results. Instead, narrative art in the nineteenth century was dominated by anecdotal subjects. Like contemporary novelists, nineteenth-century artists drew their subjects from daily life. Many were still devoted to moral messages, as proselytized at the Royal Academy, but they chose popular, modern narratives to point out the vices of the day. This shift in narrative modes was related to the changing social and economic structure of English society. In the nineteenth century there was a breakdown in universally-held beliefs, and a fragmentation of the public. The large, new art-buying public did not draw upon a shared fund of literary knowledge but preferred new

kinds of narrative that were instantly understandable. Many nineteenth-century artists, such as John Everett Millais (No. 21), turned to contemporary subjects which they presented with great immediacy and realism, thus touching the senses and sentiments at first glance and involving the spectator in the narrative process. These narratives were based on common, daily experiences which could be understood by the widest possible public.

The range of narrative art continued to expand in the nineteenth century, incorporating new subjects such as the fantasy art of Richard Doyle (No. 20). But, with the move to abstraction in late nineteenth/early twentieth century art, book illustration became the primary vehicle for narrative art. For English artists it would seem that the close association between word and image in book illustration provided a particularly fertile field for artistic invention.

Several selections in this catalog trace the development of the strong narrative tradition in English book illustration. These examples also demonstrate the various func-

tions of book illustrations. Many book illustrations, such as Walter Crane's decorative design (No. 22), were meant primarily as an embellishment or adornment to a text. Most of the book illustrations selected for this catalog, however, show the various attempts by illustrators to expand the dramatic meaning of the text. With the works of accomplished seventeenth-century artists such as Francis Barlow (No. 1), book illustration became one of the principal outlets for interpretive visual narratives. This trend continued in the works of early eighteenth-century illustrators such as Anthony Walker (No. 4), and culminated in the designs of late eighteenth-century illustrators such as Thomas Stothard (No. 9) and William Blake (No. 14). The illustrative narrative tradition continued to flourish during the nineteenth century in the illustrations created by artists such as William Holman Hunt (No. 19). Book illustration proved to be a successful vehicle for English narrative art.

This selection of drawings and watercolors also displays

the diverse functions of works of art on paper, including studies for mural and easel paintings, drawings for prints and book illustrations, preliminary designs used for silver plate and other decorative art, and finished exhibition watercolors. A flexible media, drawings and watercolors provided the means for working out a wide range of effective gestures, poses, expressions and styles, that is visually appropriate for conveying a story.

## 1. **Francis Barlow** (1626?-1704)

During a period when English art was dominated by foreigners, Barlow was one of the first native artists to gain recognition. A painter, illustrator, and engraver, he was noted then, as now, for his animal and sporting subjects. Little is known of his professional or personal life.

### *The Pedlar and His Ass*, c. 1668

Pen and brown ink with gray wash; blackened on verso (for tracing); 10 1/4"x7 1/2"

Inscribed: [verso] 6

Engraved: The drawing was etched by Richard Gaywood in reverse to illustrate Fable XXXIX, "Of the Pedlar and his Ass," in John Ogilby's *Aesopic's or a Second Collection of Fables Paraphras'd in Verse* (London, 1668), facing p. 101.

Provenance: H. S. Reitlinger; Gilbert Davis

Acquired: 1959 (59.55.62)

Note: *See Robert R. Wark, Early British Drawings in the Huntington Collection 1600-1750 (San Marino, 1969), p. 17.*

According to legend the fables of Aesop were created in the sixth century B.C. by a Thracian slave. Throughout history, however, many societies have invented similar narratives with animals portraying human moral dilemmas. The enduring popularity of Aesop's fables is probably partly because there has never been a definitive text, a cir-

cumstance which provided a fertile opportunity for literary and artistic invention. Illustrations were added to the fables beginning with their appearance in medieval illuminated manuscripts and increasing with the advent of printing. The first illustrated printed book of Aesop's fables appeared in 1461; many came later.

From the mid-1660's until the end of his career Barlow provided illustrations to several different publications of Aesop's fables, including editions which he published and sold himself. Many of the drawings for his Aesop projects are now in the British Museum. The Huntington drawing is for volume II of the second edition of John Ogilby's collection of the fables, published in 1668. Fifty new fables were added in this edition. Barlow provided approximately half of the thirty-eight new illustrations created for this publication. Wenceslaus Hollar designed the remaining plates with the exception of one plate by Josiah English.

In this fable a man is unable to move his stubborn animal until he resorts to strong threats. The rather harsh ring to this story, typical of most early moral tales, is evident in the concluding text which reads: "Moral. Such Criminalls whom soft nor threatning words / Will make confess, cock'd Pistolls, nor drawn Swords; / Tell them of Tortures and Infernall flames, / That brings all out, and greatest Monsters tames."

Barlow's designs are notable for the emphasis he places on dramatic action. The diagonals which organize the arrangement of the figures and landscape in the Huntington drawing activate and animate the composition. He

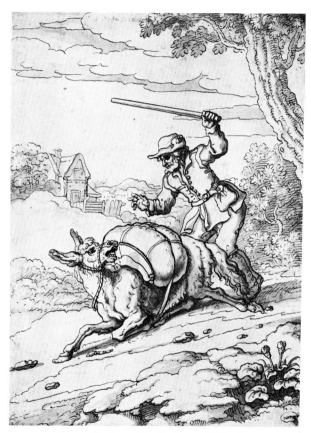

Francis Barlow: *The Pedlar and His Ass*

7

heightens the drama by endowing his animals with emotions. There is a direct, dynamic interaction between the master and his ass. The actions of the one are reflected in the face and pose of the other. Barlow's life studies also give the narrative greater verisimilitude. The anatomy and proportions of both animal and human are more naturalistic than in earlier book illustration. The inclusion of a convincing environment as a setting for the action also adds to the credibility of the narrative.

The Huntington drawing is executed, as most of Barlow's drawings, in brown pen and gray wash. A pen and wash technique was widely utilized by English draftsmen in both the seventeenth century and the eighteenth. In this case the technique is particularly appropriate for a preliminary drawing for an engraving. The pen lines boldly outline the forms and facilitate their transfer to the engraving plate. Barlow engraved many of his own designs and may have had printmaking in mind when creating his drawings. His pen lines, however, have a verve that is lost in the prints. The flat, gray washes which model the forms in the drawing create a rich coloristic contrast to the brown pen lines and an attractive pattern which also is lost in the engraving process.

## 2. James Thornhill (1675/6-1734)

Thornhill, the father-in-law of Hogarth, was the most distinguished British mural painter of his day. Born in Dorset, he was apprenticed to the painter Thomas Highmore. He traveled to Italy to continue his training and also studied the English works of the Italian ceiling painters Verrio and Laguerre. His many important commissions included the vast ceiling and wall schemes in the Painted Hall at Greenwich which occupied him from 1708 until 1727. He was appointed Sargeant-painter to the king and was knighted. In the 1720s the rival Lord Burlington and his protege William Kent rose to power and Thornhill's baroque style fell from favor. Through the private academy which he ran in his house, however, Thornhill remained an influential figure in the arts.

### Wall Design with Diana and Actaeon

Pen and brown ink with gray wash; 6 3/8″x11 3/8″

Inscribed: [below in ink] Apollo/20 ft 8 in/Diana [above in pencil] Diana & Actaeon. Ovid Metamorph: Lib. 3 [verso in pencil in a later hand] Hall [?] Th Willough [?]

Provenance: Sir Robert Witt; Sir Bruce Ingram

Acquired: 1963 (63.52.262)

Note: *Three related designs of* Diana and Actaeon *are contained in a Thornhill sketchbook in the British Museum. See also, Robert R. Wark, Early British Drawings in the Huntington Collection 1600-1750 (San Marino,*

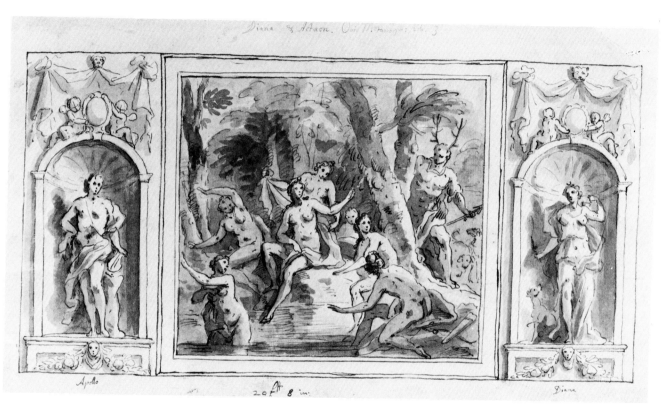

James Thornhill: *Wall Design with Diana and Actaeon*

*1969), p. 49; Edward Croft-Murray,* Decorative Painting in England, *I (London, 1962), p. 274.*

This design probably was executed for Sir Thomas Willoughby at Wollaton Hall where Thornhill worked at an unknown date. The subject was not, however, incorporated into the finished decorative scheme. The story recounts the myth of Diana and Actaeon, best known from Ovid's *Metamorphoses.* In this tale the hunter Actaeon comes upon Diana as she is bathing with her nymphs. Affronted by being seen naked, she turns him into a stag. Actaeon is then chased and killed by his own hounds. Thornhill's drawing depicts the moment when Diana transforms Actaeon into a stag; the horns have already appeared on his head. This famous theme from classical literature is characteristic of the narrative subjects chosen by Thornhill and his contemporaries for ceiling and wall decorations both in England and on the continent. It continues an older tradition of mural painting which reached its apogee in the vast decorative schemes in Italian baroque buildings.

Thornhill has developed a decorative framework for his narrative scene, a manner of organization established in earlier mural paintings. The frame around the central panel functions as a proscenium arch and creates the effect of looking through a window to an outdoor scene. The flanking figures simulate sculpture placed in niches in the wall. These illusionistic, spatial effects, so typical of full baroque art, are somewhat mitigated by Thornhill's drawing style. His nervous, rather staccato pen lines and flat, fluttering washes create a lively surface animation. These two-dimensional decorative effects are more in keeping with rococo art, a style which was to dominate Europe by the middle of the eighteenth century. Thornhill's drawing represents a transitional phase in this stylistic development.

### 3. **James Hulett** (died 1771)

As often with early English artists, little is known of the life of this illustrator and engraver. A press cutting of January 28, 1771 in Horace Walpole's *Book of Materials* in the Lewis-Walpole Library, Farmington, Conn., reads: "On Wednesday last died Mr Hulett, an Eminent Engraver in Red Lion-street, Clerkenwell. He was the Person who engraved the Cuts to the first edition of Fielding's celebrated Novel, Joseph Andrews [1743]."

### *L-d M--n's Divertion,* c. 1746

Pen and gray wash; indented with extensive traces of engraver's red chalk on the reverse; watermark "IV"; 8 1/2"x10 1/2"

Engraved: The drawing was engraved by J. Hulett in reverse in 1746

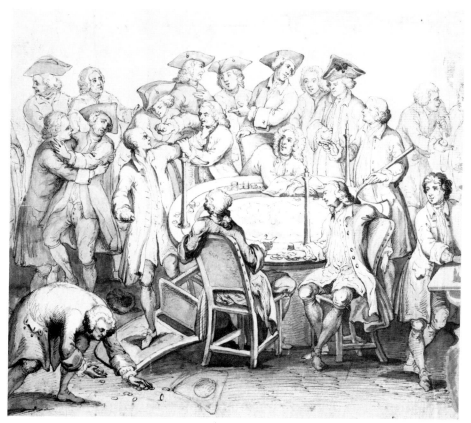

James Hulett: *L-d M—n's Divertion*

Provenance: Vice-Admiral Lord Mark Kerr; with his descendants until 1983

Acquired: 1983 (83.3)

Note: *A print after this drawing is located in the British Museum, Department of Prints and Drawings (George No.2827). It bears the imprint "L-d M--n's Divertion., J. Hulett sculp." The print, which measures 10 5/8"x12", extends on both sides and the top beyond the drawing, an interior architectural setting has been added, minor details are altered, and one figure has been added to the background group on the right in drawing. Below the plate the following lines are engraved:*

> *In Picture, here, the Gaming Table view,*
> *And all the Passions of the gaming Crew;*
> *Where Villains, vers'd in every vile Deceit,*
> *Men of high Birth & noble Fortune meet;*
> *Who, stranger still! devoid of Sense & Shame,*
> *Stake against Ruin,—Quiet, Wealth and Fame.*
>
> *Sharpers on Fools, as Pikes on Gudgeons prey;*
> *But wiser Gudgeons keep themselves away*
> *From the Destroyer's Haunts; Fools thither run,*
> *And Spite of all Forewarnings are undone.*
>
> *To the Prudent in General: This Plate is humbly Inscrib'd by*
> *their most obedient Servt. James Hulett.*

*This plate also was issued with the title altered to* Covent Garden Gaming Table *and a publication line inserted which reads "London printed for John Ryall in Fleet Street." See* Catalogue of Prints and Drawings in the British Museum. Division I. Political and Personal Satires, *by E. Hawkins and F. G. Stephens, later continued by D. M. George, No. 2828. "L-d M--n" has been identified as George Douglas, 4th Lord Mordingtoun. See Christie, Manson & Woods LTD.,* Important English Drawings and Watercolors, *Tuesday 29 March 1983, lot 7.*

This gambling house scene probably represents George Douglas, 4th Lord Mordingtoun in Covent Garden where he died in 1741. Hulett has chosen to illustrate a subject taken from everyday life rather than record the exploits of mythological gods or kings. There was a decline in narrative paintings devoted to grand themes during the first half of the eighteenth century when portrait painting was the predominate mode in England. Narrative art does continue during this period but, for the most part, only in prints and book illustrations devoted to contemporary literature and scenes from modern life. The central theme of these modern moral subjects, such as Hulett's, is often concerned with the follies and vices of the day. William Hogarth, who described himself as a comic history painter, did the most to popularize this new narrative subject matter.

Hulett engraved this work himself. Hogarth also frequently engraved his own works, and sold the prints himself, promoting them in newspapers for further exposure. English artists utilized prints to reach a new audience, the burgeoning middle class, and thus become less dependent upon the traditional patronage system.

This drawing bears all of the characteristics of the rococo style. An international style, the rococo flourished in England during the middle of the eighteenth century. The fluttering squiggles of Hulett's pen lines and his spotted light and shadow patterns which play over the entire composition create an allover sense of surface animation. The circular arrangement of the figures around the oval gaming

table calls attention to the compound curves which operate throughout the composition. The two-dimensional organization, with little spatial development, further enhances the flat, essentially decorative treatment characteristic of the rococo style. The decorative handling of the scene is somewhat at odds with the moral didacticism of the subject matter.

## 4. Anthony Walker (1726-1765)

Born in Yorkshire, Walker studied at St. Martin's Lane Academy in London. From 1760 to 1765 he exhibited at the Society of Arts. He was an engraver and book illustrator, as was his brother William.

### Romeo and Juliet (Act 5 Scene 3), c. 1753

Pen and gray wash; 8 1/4"x5 3/4"

Engraved: The drawing was engraved by Anthony Walker in reverse

Provenance: Thomas Turner of Gloucester; Ellesmere Library

Acquired: 1917 (181067.XLI.258)

Note: *The drawing is one of fourteen drawings by Walker bound into*

*the Huntington Library's edition of Shakespeare's* Plays *extra-illustrated by Thomas Turner of Gloucester beginning in 1835. Prints after many of these designs also are included in the Turner Shakespeare. The prints for* Romeo and Juliet *bear Walker's name as designer and engraver. See* Robert R. Wark, Drawings from the Turner Shakespeare *(San Marino, 1973), p. 49.*

Three of the four Walker drawings for *Romeo and Juliet* in the Huntington are signed and dated 1753. David Alexander's collection, York, England, contains an engraving by Walker after his design for *Romeo and Juliet* (Act 1 Scene 7) which carries the publication date of January 15, 1754. Alexander also has discovered an advertisement in the *Public Advertiser,* Jan 21, Feb 11, 1754 which reads as follows:

This Day are published Price 3s Printed on Five Half Sheets of Superfine Paper FIVE Principal Scenes in ROMEO and Juliet. Designed Drawn, and Engraved by Mr Ant. WALKER Printed and sold by John Tinney, at the Golden Lion, in Fleet Street The Drawing and Engraving of the three following Plays of Shakespeare are in great Forwardness, and the Scenes of each Play will be sold at a Time, viz HENRY IV, The First Part HENRY IV, The Second Part, and THE MERRY WIVES OF WINDSOR. These Plates will serve for Mr Pope's Edition of Shakespeare in Quarto, Sir Thomas Hanmer's Edition, 6 vol Quarto, or for any of the Folio Editions And may be framed and

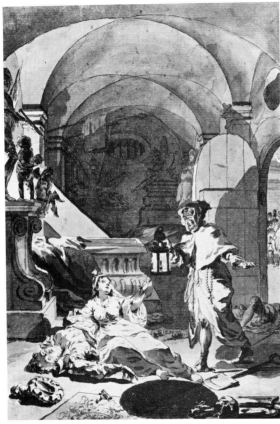

Anthony Walker: *Romeo and Juliet (Act 5 Scene 3)*

glazed for Furniture There will be a few Sets neatly coloured for Gentlemen and Ladies who chuse them so.

This evidence suggests that separate prints after some of Walker's Shakespeare designs were issued in the mid-1750s. The supposition is supported by the fact that Walker exhibited *Scenes from Shakespeare* at the Society of Art in 1760. The prints were probably reissued in 1795. Four of the prints in the Turner Shakespeare bear the publication line January 15, 1795, Mno Bovi, No. 207, Piccadilly.

Numerous editions of Shakespeare, usually elaborately illustrated, were produced in the eighteenth century as a result of the new nationalistic concern with British literature, especially Shakespeare and Milton. The tremendous upsurge of interest in illustrations to Shakespeare culminated at the end of the century in Boydell's ambitious Shakespeare Gallery.

Walker's drawing style reflects the profound influence of the French rococo illustrator Hubert Gravelot on English book illustration dating from his sojourn in London in the 1740s. The dappled washes and flickering, broken lines create a sense of excited movement across the surface of the drawing, as do Gravelot's rococo designs. The delicacy of Walker's pen lines adds to the overall elegance of the drawing. This refined, decorative style was particularly effective in rendering gay, light-hearted effects. It was successful for illustrating pastoral and comic scenes. The idiom

could not be adjusted to the more emotional demands of high tragedy. In Walker's rendition of this climatic moment from *Romeo and Juliet* the eye is distracted from the main characters by the many subsidiary details highlighted by the spotted lights. This tends to diffuse the emotional situation. The rococo style remained, however, the predominant choice for book illustration because of its decorative nature. For most of the eighteenth century book illustrations were meant primarily as "embellishments" or visual adornments to the text.

### 5. Henry Fuseli (1741-1825)

Johann Heinrich Füssli or Henry Fuseli, as he was called in England, was born in Zurich to a family distinguished for its cultural accomplishments. He received an extensive classical education and associated with many of the noted intellectuals of his day, including the philologist J. J. Bodmer and physiognomist J. C. Lavater. His literary and antiquarian interests took him on many travels, including a journey to England in 1764 where he was encouraged by Reynolds to become a painter. From 1770 to 1778 he studied art in Italy. While there he became an influential member of an avant-garde group of English artists in Rome.

Returning to London, Fuseli gained attention with the exhibition of his sensational painting *The Nightmare* at the Royal Academy in 1781. An active member of the academy, Fuseli was appointed both professor of painting and Keeper of the Royal Academy. He also was involved in projects of Boydell and Macklin, executing nine paintings for Boydell's Shakespeare Gallery. His efforts to promote history painting came to fruition in his Milton Gallery, for which he created forty-nine paintings. His scheme, however, met with financial failure as did those of Boydell, Macklin, and Bowyer.

### *Death of Cardinal Beaufort,* c. 1772

Pen and brown wash over red pencil; 11 1/2"x12 5/8"

Provenance: Gilbert Davis

Acquired: 1959 (59.55.545)

Note: *This drawing is a sketch for the larger and more finished drawing in the Walker Art Gallery, Liverpool. The Liverpool drawing, which is dated "Roma '72," was exhibited at the Royal Academy in 1774 and a related sketch is in the British Museum. See Robert R. Wark,* William Blake and His Circle; Two Exhibitions at the Henry E. Huntington Library and Art Gallery *(San Marino, 1965), pp. 15-16.*

This drawing illustrates the *Death of Cardinal Beaufort* from Shakespeare's *Henry VI Part II* (Act 3 Scene 3), in which the guilt-ridden cardinal faces his death with horror and trepidation. Fuseli was in the vanguard of artists in the second half of the eighteenth century who were con-

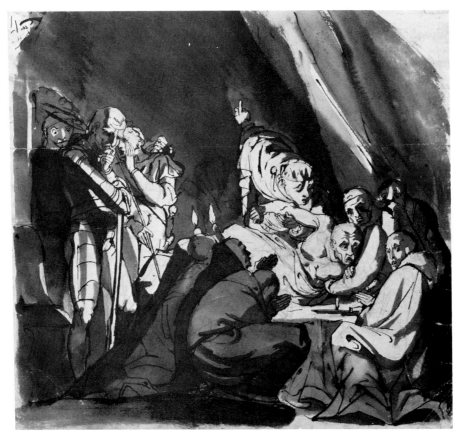

Henry Fuseli: *Death of Cardinal Beaufort*

cerned with expanding the emotional range of art. In his works, as in those of his contemporaries, one sees a shift to the subjective aspects of human experience. Emotions are represented at a maximum level of intensity with the focus on scenes of madness and despair, as in Fuseli's drawing of Beaufort. This desire for subjects that were calculated to arouse extreme emotions in the viewer led to a new range of subject matter in the arts. Such subjects would have been considered "sublime" in the eighteenth century. The sublime, as codified in Edmund Burke's seminal work, *A Philosophical Enquiry into the Origins of Our Ideas of the Sublime and Beautiful* (1757), included all that was grand and super-normal including strong and irrational emotions such as terror, horror, and ecstasy—extremes of any kind. The awesome, the terrible, and the frightening were now considered a legitimate realm for artistic expression. Shakespeare's texts were a particularly rich source for such scenes.

Aspects of this drawing, such as the Michelangelesque-figure types and the classical, frieze-like orientation of the composition, reflect the styles which influenced Fuseli and his fellow English artists in Rome. The emphasis on long, sweeping outlines, however, was first developed in England and is characteristic of the art of many late eighteenth-century English artists. Fuseli's personal mannerisms are expressed in the contortion of forms and the strong chiaroscuro effects which add to the sense of unease. In this early drawing one sees Fuseli's lifelong fascination with narrative themes devoted to violence, tragedy, pathos, and the bizarre.

### 6. **Philip James De Loutherbourg** (1740-1812)

De Loutherbourg was born in Strasbourg, studied in Paris under Vanloo and Casanova, and became a member of the French Academy before settling in England in 1771. His first work in London was as a scene designer for David Garrick. He also executed history painting, comic art, book illustration, landscape painting, and portraiture. He exhibited frequently at the Royal Academy, was elected a full academician and was appointed history painter to the duke of Gloucester in 1807. De Loutherbourg contributed to Boydell's Shakespeare Gallery, Macklin's Bible, and Bowyer's History of England. A man of remarkably diverse talents, he was also an alchemist, a faith healer, and creator of the famous panorama, the Eidophusikon.

*The Brigands*

> Pen and brown wash over pencil; 12 1/2"x17 1/2"
> Inscribed [in another hand?]: P. J. De Loutherbourg 01
> Provenance: Gilbert Davis

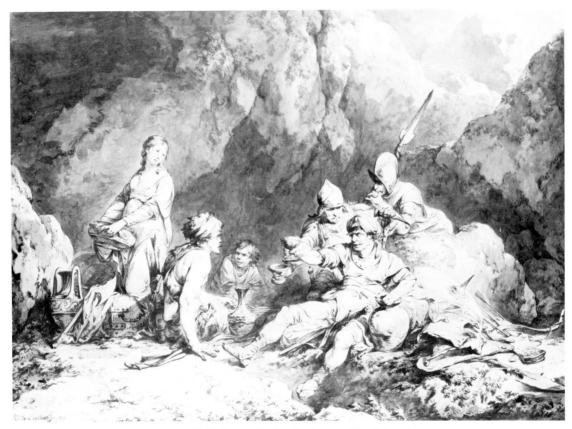

18          Philip James De Loutherbourg: *The Brigands*

Acquired: 1959 (59.55.875)

Note: *The leading De Loutherbourg scholar, Rudiger Joppien of the Kunstgewerbemuseum der Stadt, Koln, W. Germany, has suggested in a letter that the early 1770s is a likely date for the execution of this drawing. In his later years Loutherbourg signed his finished works, such as this drawing, with his full name and the initials "R. A.". The fact that these are missing indicates to Joppien that the drawing probably was executed before 1781 when he was elected a member of the Royal Academy. Furthermore, the inscription and numbers "01" do not seem to be in De Loutherbourg's hand and perhaps were added at a later date. According to Joppien this drawing was probably executed during the transition period in the artist's career between his stay in France and his move to England.*

De Loutherbourg's first paintings and prints devoted to banditti appeared in the early 1760s. The popularity of the banditti subjects of the English artist John Hamilton Mortimer may have encouraged him to continue with this subject matter upon his arrival in London. Both artists were deeply influenced by the works of the seventeenth-century artist Salvator Rosa. Like Rosa's banditti scenes, this drawing illustrates an unspecified narrative concerning the life of the outlaws of the Abruzzi in Italy. As did Rosa, De Loutherbourg attired his banditti in breast plates, helmets, fur turbans, and feathers. He further heightens the emotional appeal of this scene by placing the banditti in a sublime mountain setting. This interest in exotic locales and marginal life styles is part of the avid pursuit of new artistic sources in the late eighteenth century and reflects a new desire to widen the range of expression in the arts.

This finished, rather large drawing was probably meant as an end in itself, rather than to function as a study for an oil painting. It may have been intended for engraving, although no print is known. As opposed to most contemporary English artists, De Loutherbourg utilizes shadowing rather than line to create his dramatic expressive effects. His reliance on brown washes to create rich chiaroscuro probably reflects his continental training.

### 7. **Benjamin West** (1738-1830)

West was born in Pennsylvania to Quaker parents. At an early age he established himself as a portrait painter in Philadelphia and New York. To pursue his artistic studies he left for Italy in 1760 never to return to America. West settled in London in 1763 becoming a founder member of the Royal Academy and its second president after the death of Reynolds. He also gained the support and patronage of George III and was appointed historical painter to the king and surveyor of the royal pictures.

*Sketch for "The Death of the Earl of Chatham,"* c. 1778

Black, red and white chalk on blue paper; 5 1/4"x6 1/2"

Provenance: the Margary family by direct descent from the artist

Acquired: 1969 (69.6)

Note: *David M. Robb, Jr. states in an unpublished paper presented at the College Art Association convention in 1983 that this drawing is a study for the oil painting,* The Death of the Earl of Chatham *(28 1/2"x36 1/4"), now in the Kimbell Art Museum, Fort Worth, Texas. Robb dates the Kimbell painting to 1778. It is an advanced study for an unrealized final version. According to Horace Walpole:*

> *Mr West made a small Sketch of the death of Lord Chatham, much better expressed & disposed than Copley's. It has none but the principal person's present; Copley's almost the whole peerage, of whom seldom so many are there at once, & in Copley's most are mere [sic] spectators. But the great merit of West is the principal Figure which has his crutch & gouty stockings, which express his feebleness & account for his death. West [would] not finish it not to interfere with his friend Copley. (Book of Materials, 1771, p. 113 [1785], Lewis-Walpole Library, Farmington, Conn.)*

*Copley worked on the* Death of Chatham *from 1779 to 1781; thus one may assume that West's preliminary drawings date about 1778.*

This drawing is a record of the events which occurred on April 7, 1778. In a speech to the House of Lords, the duke of Richmond argued for the withdrawal of the British armed forces from the American colonies. Chatham, who had been infirm for some time, rose to rebut Richmond and plead for the continuation of the war. He collapsed soon afterwards and died the next month.

West's depiction was meant as both a believable record of this event and an act of homage to its principal character, Chatham. To do this he relied on the devices he so effectively utilized in *The Death of Wolfe* which he exhibited at the Royal Academy in 1771. That painting had such a popular reception that West decided to take it on a tour, exhibiting it to large crowds for a modest admission fee, thus reaching and forming a new market for history paintings of modern life. His rendition of this topical event gave renewed validity to the use of contemporary events as an appropriate vehicle for grand, lofty emotions. To enoble his modern subjects West made allusions in his works to great art of the past. In the Huntington study for *The Death of Chatham* the pose of Richmond is based on the well-known figure from classical art of a Roman orator. The hero, Chatham, is modeled on the dead figure of Christ in representations of the Pieta, as was the figure of Wolfe in *The Death of Wolfe*. In the arts, such emphasis on death and heroism elevates mere reportage to the realm of the sublime.

Two preparatory drawings exist for *The Death of Chatham*, the Huntington drawing and a study in black chalk on blue paper in the Morgan Library which probably was executed earlier (see Ruth S. Kraemer's *Drawings by Benjamin West and his son Raphael Lamar West* [The Pierpont Morgan Library, 1975], pp. 14-15 and plate 20). In the Huntington drawing the figures in the background have been reduced in size and number, while the two principal figures have been moved into the foreground, giving them

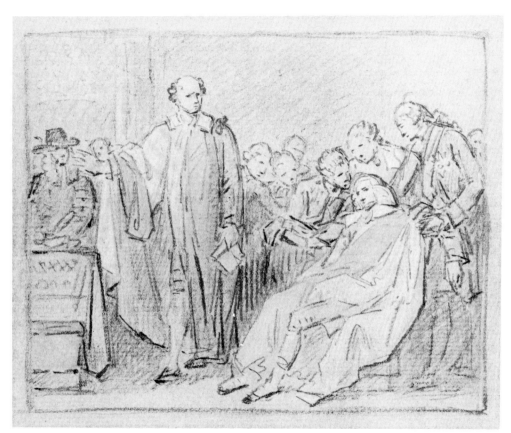

Benjamin West: *Sketch for "The Death of The Earl of Chatham"*

greater emphasis and enhancing the narrative clarity. West, like many contemporary English artists, has arranged the composition in a shallow, frontal plane reminiscent of classical art. The poses and overall organization are static, but the rapid thrusts and jabs of his chalk lines add a sense of vitality that is often lost in the oil versions. The juxtaposition of black, white, and red chalks with a deep blue paper increases the freshness and vibrancy of the drawing.

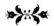

### 8. **Thomas Gainsborough** (1727-1788)

Gainsborough was born in Sudbury, Suffolk. At fourteen years of age he was sent to London to study at St. Martin's Lane Academy with the rococo artists Hubert Gravelot and Francis Hayman. He returned in 1748 to Sudbury, soon afterwards settling in Ipswich as a portrait painter. In 1759 he moved to Bath where he found a more fashionable clientele. He began exhibiting in London in 1761 and was a founder member of the Royal Academy, but did not move to London until 1774. One of the most renowned and celebrated of eighteenth-century English portrait and landscape painters, Gainsborough rarely turned to narrative art.

*Diana and Actaeon*, c. 1784-85

Monochrome wash, heightened with white on buff paper; 11"x14 1/2"

Inscribed: [in pencil on the old mount bottom right] Gainsboro.

Provenance: [?] Sir Thomas Lawrence; Canon F. H. D. Symthe

Acquired: 1961 (61.27)

Note: *John Hayes, a leading Gainsborough scholar, suggests on stylistic evidence that this subject was painted in about 1784-85. He argues convincingly that Gainsborough's uncharacteristic choice of this mythological narrative probably was part of a self-conscious attempt to demonstrate the variousness of his style in the early to mid 1780s. See John Hayes,* The Drawings of Thomas Gainsborough *(London, 1970), pp. 295-96; see also Robert R. Wark,* Gainsborough and the Gainsboroughesque. An Exhibition of Drawings and Prints at the Henry E. Huntington Library and Art Gallery *(San Marino, 1967), p. 10.*

Three drawing studies for the painting *Diana and Actaeon* survive: one in the collection of the marchioness of Anglesey, Plas Newydd, the Huntington drawing, and a study in the Cecil Higgins Art Gallery, Bedford; the existing oil painting is located in the British Royal collection. It was unusual for Gainsborough to execute this many studies for a painting, which may indicate that he encountered unfamiliar problems with a narrative theme. It is the only subject from classical mythology in Gainsborough's *oeuvre*. This also may explain why the painting, which has several pentimenti, was never finished.

All of the studies illustrate the moment in the narrative

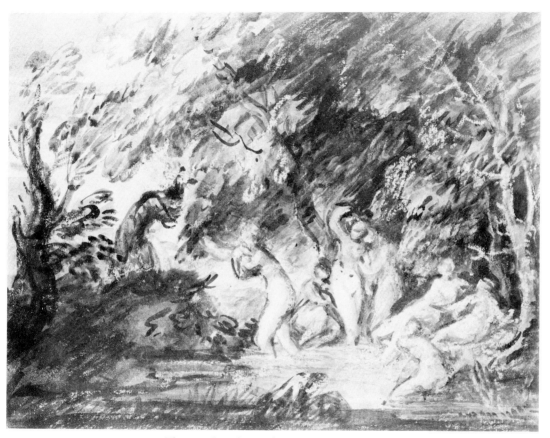

Thomas Gainsborough: *Diana and Actaeon*

23

when the goddess Diana throws a handful of water at the intruder Actaeon changing him into a stag to be torn to pieces by his own hounds. This dynamic gesture, which appears in all of the versions, gives the narrative an immediacy absent from Thornhill's depiction of this myth (see No. 2). Although Gainsborough's rendition may seem more spontaneous, he, as so many of his fellow English artists, depended on earlier art to elevate his narrative theme to history painting. In this case several of the bathing nymphs are based on classical prototypes.

Throughout his career Gainsborough worked in a variety of drawing media, frequently mixing techniques. In the Huntington drawing he utilized broadly applied washes to create fluid, undulating contours. These diaphanous washes seem to flow effortlessly across the surface of the paper, uniting all of the elements of the composition, both figures and landscape, into one lyrical pattern. The very personal, almost calligraphic, rhythms of his brushwork heighten the emotional tone. Gainsborough also relied on tinted papers, such as the buff paper of this drawing, to add further resonance to his monochromatic color scheme.

## 9. **Thomas Stothard** (1755-1834)

Stothard was born in London and apprenticed to a Spitalfield silk designer. He entered the Royal Academy Schools in 1777, subsequently becoming a full member of the academy as well as the Royal Academy Librarian in his later years. A close friend of John Flaxman and William Blake in his youth, Stothard developed a style of book illustration that was very influential in his day. A prolific artist, he also executed oil paintings, landscape drawings, and designs for silver, porcelain, and a wide range of ephemeral objects.

*Lovelace's Dream*, c. 1784

> Pen and gray wash; 4 1/2"x3"
>
> Engraved: The drawing was engraved on July 10, 1784 by Walker in reverse for Samuel Richardson's *Clarissa Harlowe*, published in John Harrison's *The Novelist's Magazine* (1784), plate XXX.
>
> Provenance: unknown
>
> Acquired: 1968 (68.7.I)

Note: *Stothard provided 244 illustrations for Harrison's* The Novelist's Magazine *between 1780 and 1786. He created 28 designs for* Clarissa, *thirteen of which are in the Huntington collection.*

After the revocation of the perpetual copyright law in 1777, booksellers such as John Harrison began to publish collections of reprints, including Richardson's *Clarissa*, first published in 1747-49. To maintain a low price, they issued

publications like *The Novelist's Magazine* in parts. These weekly numbers sold at about sixpence each. Although there is no evidence concerning the size of these editions, their consistently low cost indicates that their publishers were attempting to reach a widespread market. Because publishers recognized that the appeal of these cheap reprint series lay in their illustrations as much as in their literary content, they were careful to select the best illustrators of the day, in particular, Stothard. Both his style and manner of interpretation appealed to this new audience.

*Lovelace's Dream* is a scene of major importance in the story. Stothard's drawing depicts Lovelace's vision of Clarissa's apotheosis which prefigures her later death due to his machinations. The scene is fraught with moral and quasi-religious symbolism. Both text and illustration were directed to the sympathies and compassion of the reader with author and artist relying on the female figure—often in distress—as their chief vehicle of emotional appeal. The eighteenth-century conception of the ideal woman is captured in Stothard's depiction of Clarissa: she is very young, fair, and so delicate both physically and mentally that she faints (or, in Clarissa's case, dies) if her virtue is threatened. Delicacy and fragility of constitution were associated with a delicacy of feeling, the keynote of sentimentalism, a phenomenon which dominated much late-eighteenth century art and literature. Stothard was renowned for his ability to capture these tender sentiments.

Stothard's flowing, swinging contour lines effectively ex-

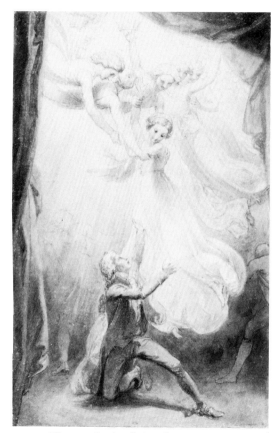

Thomas Stothard: *Lovelace's Dream*

press the graceful movements of this childlike woman. His long, swelling lines add a fluid quality to the two-dimensional surface rhythms. These gliding, undulating contour lines gather together the diffuse energy of earlier rococo designs into a more readable structure. The underlying linear structure has simplified and quieted the surface animation, but the style remains essentially decorative, appropriate for embellishing and enriching a text. This modified rococo style, as developed by Stothard, dominated book illustration well into the nineteenth century.

## 10. **George Romney** (1734-1802)

Born in Beckside, near Dalton-in-Furness, Romney was apprenticed to the portrait painter Christopher Steele in York and Lancaster. In 1762 he settled in London. His artistic studies took him to Italy from 1773 to 1775. Upon his return Romney gained recognition as a fashionable portrait painter and chief rival to Gainsborough and Reynolds. His health and mental well-being deteriorated in the years before his retirement to Kendal in 1798. Romney was never affiliated with the Royal Academy. He did, however, devote much of his artistic energies to serious narratives from

history and literature, winning a premium from the Society of Arts for his history paintings in 1763 and 1765.

### *Study for "Cassandra Raving,"* c. 1788-91

Pen and monochrome wash; 18 1/2"x10 3/4"

Provenance: Haas

Acquired: 1966 (66.14.25)

Note: *A leading Romney scholar, Patricia Jaffe, suggests that this drawing is a study for Romney's painting of Emma Hart as* Cassandra Raving. *A related drawing is in the Folger Shakespeare Library. The painting, now in the collection of Tankerville Chamberlayne, was included in Boydell's Shakespeare Gallery in 1791. Jaffe alludes to evidence which suggests an earlier date for the initial conception. She dates the Romney drawing of a* Seated woman and child *which is on the verso of this Huntington drawing to 1788-91. See* The Drawings of George Romney: An Exhibition *held from May to September 1962 at the Smith College Museum of Art Northampton, Mass., no. 69.*

Although his livelihood depended on his facility as a portrait painter, Romney's true interest lay in history painting. Throughout his career he filled sketchbooks with drawings of literary and historical subjects. Most of these narrative projects did not, however, extend beyond the drawing stage. Four of his narrative subjects that were executed as paintings are associated with Boydell's Shakespeare Gallery. Romney, a member of a memorable dinner party at Josiah Boydell's in 1786, proposed a "National Gallery" of pictures painted from Shakespeare's plays which would advance the cause of history painting in England. The idea was taken up by the printseller John

Boydell, who also was eager to reach the new mass market for prints. Boydell commissioned paintings from the leading English artists and exhibited them in his Shakespeare Gallery in Pall Mall beginning in 1793. He also issued two sets of engravings made from the paintings. One set served as book illustrations to an edition of the plays. A larger set, including *Cassandra Raving*, was issued as individual prints which were later bound together in a folio volume published in 1803. Boydell's ambitious project met with failure when the foreign print market collapsed during the Napoleonic Wars.

This Romney drawing, a study for his painting of *Cassandra Raving*, illustrates Act 2 Scene 2 of *Troilus and Cressida*. The figure of Cassandra probably represents Romney's favorite portrait subject of this period, the famous beauty Emma Hart, soon to be Lady Hamilton and subsequently the mistress of Lord Nelson. The painting was engraved by Francis Legat. The print bears the publication date of January 1, 1795 and the legend "CAS. Cry, Trojans, cry! Lend me ten thousand eyes and I will fill them with prophetic tears."

The two-dimensional patterning of Romney's contour lines, the flat washes and the lateral orientation to his composition link his work of this period to that of his contemporaries, especially Flaxman, Blake, and Stothard. These artists were similarly concerned with developing an expressive linear style. Romney's bold, free pen lines and his strong light and dark patterns enhance the drama of

George Romney: *Study for "Cassandra Raving"*          27

this wild, prophetic scene. There is a barely controlled frenzy and abandon to his sweeping lines. His energetic, rapid execution adds a sense of dramatic immediacy. To elevate this thinly-disguised portrait subject to the level of sublime history painting, Romney has utilized a pose reminiscent of classical art.

## 11. **Thomas Rowlandson** (1756-1827)

Born in London, this prolific comic draftsman made frequent trips to the continent, particularly to Paris. Although he never became a member of the Royal Academy, Rowlandson was trained in the Royal Academy Schools and exhibited at the academy from 1775 until 1787. In the late 1790s he began his productive association with the publisher Joseph Ackermann, creating numerous illustrations for his popular publications such as *The Microcosm of London* (1808-11) and the *Three Tours of Dr. Syntax* (1812-21).

### *A French Frigate Towing an English Man O'War into Port*, c. 1790

Pen and watercolor over pencil; 10 5/8"x8 1/2"
Inscribed: [in pencil on old mount, probably in a later hand] A French frigate towing an English Man of War into Port

Provenance: H. Reveley, [?] Joseph Grego; Madan; Gilbert Davis

Acquired: 1959 (59.55.1105)

Note: *Based on stylistic evidence Robert Wark suggests a date of about 1790. See Robert R. Wark,* Drawings by Thomas Rowlandson in the Huntington Collection *(San Marino, 1975), pp. 56-57.*

In England in the late eighteenth century new categories of narrative subjects, including humorous subjects, were considered legitimate forms of expression for artists of high ambition. For the first time comic art attained professional status and was exhibited at the Royal Academy. Rowlandson was one of the most prolific and accomplished of the many comic draftsmen who flourished during this period.

This drawing shows an encounter between a sailor and a prostitute but verbally identifies the subject as British and French ships. Thus, the title does not function as a descriptive caption and the humor evolves in the interrelationship between the words and the image. The one is esssential to the other. Rowlandson was not the originator of this clever idea. In 1781 Carrington Bowles issued a series of anonymous prints with the same sort of subject matter and related nautical captions. One print is entitled *A Man of War Towing a Frigate into Harbour* (George 5954). These prints are illustrated in Charles Napier Robinson, *The British Tar in Fact and Fiction* (London, 1909),

pp. 166, 172, 296.

Rowlandson, however, was more adept than his predecessors at exploiting the humorous potential of this subject. He adds comic action and caricature, or the expressive exaggeration of some physical characteristic, to heighten the humor of the situation. His stylistic treatment of the scene is equally important in creating an overall sense of merriment. Rowlandson's bouncing, calligraphic pen lines and pretty, pastel watercolors produce pleasing decorative effects which reinforce the light-hearted tone. This decorative treatment also softens the often sinister aspects of caricature. His use of a gay, decorative color scheme and curving, rolling lines allies his art to the rococo. His choice of a rococo style and a pen and watercolor technique may have been inspired by French examples encountered on his trips to Paris. Rowlandson's technical facility as a draftsman is evident in the swelling and tapering pen lines which add a sense of exuberance and vitality to the whole watercolor.

## 12. **James Gillray** (1757-1815)

Born in Chelsea, Gillray was apprenticed to an engraver but ran away to join a company of strolling players. After

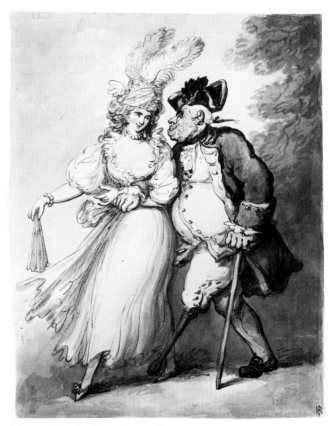

Thomas Rowlandson: *A French Frigate Towing an English Man O'War into Port*

he returned to London he entered the Royal Academy Schools in 1778. His first satirical prints were issued in about 1780 and quickly established his reputation as an acute social and political commentator. Gillray's artistic output was prodigious until about 1811 when he became insane.

## Satire based on Pope's "Eloisa to Abelard"

Pen and brown wash over red and black pencil; 18"x11 1/2"

Inscribed: [top left] Evening or a Zapherous [?] Idea / What means this tumult in a Vestals Veins / Eloisa; [top right] Morning or I Delight of ye groves [?] / Ye Groves which . . . / Pope

Provenance: unknown

Acquired: 1966 (66.22)

Note: *"What means this tumult in a Vestal's veins" is from Pope's* Eloisa to Abelard *(line 4).*

In the late eighteenth century there was an upsurge of interest in political and social satire in English art. Approximately 8000 satirical prints published between 1770 and 1815 are contained in the British Museum collection. Much of this work reflects the tastes of aristocratic amateurs who would often commission finished prints based on the ideas they supplied to professional artists. Most comic artists, including Gillray and Rowlandson, executed such special commissions. Amateur patrons also were the principal market for the professional artist's own satirical prints. Both amateur and professional comic artists attacked the social excesses and political folly of their contemporaries from all ranks of life. No one was left unspared. Indeed, Gillray worked for both political parties at different times in his life. Although the humor in these satirical narratives often seems brutal to twentieth-century eyes, it was relished at the time.

The female figure in the Huntington drawing resembles Gillray's depiction of Emma Hamilton in his print *Dido in Despair* (1801), but the subject is as yet unidentified. In most of his works, as in this drawing, Gillray relied heavily upon caricature, the exaggeration, usually for comic purposes, of some salient physical characteristic. In his hands caricature often approaches the grotesque. Gillray has further heightened the expressive impact of his design by the manner in which he organized his composition. In this drawing he divides the composition into two scenes and contrasts them in a manner that would quickly create a humorous juxtaposition: skinny vs. fat, exterior vs. interior setting, etc.

Although Gillray seems to have used preparatory sketches for his prints, few now survive. In the Huntington drawing, which is probably a preliminary design for an as yet unidentified print, Gillray began with both red and black pencil, then continued to develop the design with pen and wash. He uses very free, vigorous lines to work out dramatic chiaroscuro effects, rather than the two-

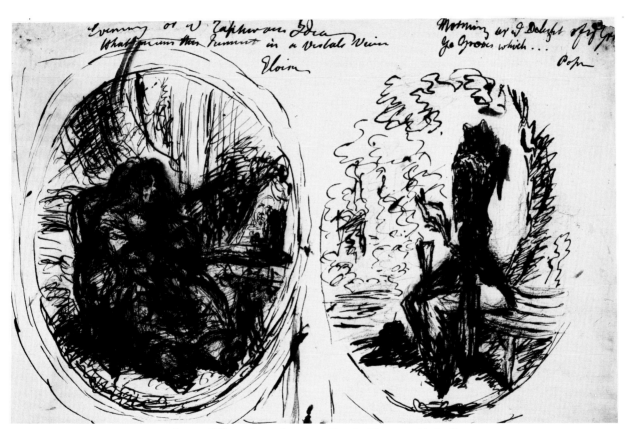

James Gillray: *Satire based on Pope's "Eloisa to Abelard"*

dimensional decorative patterns characteristic of Rowland-son. Gillray's dark pools of ink and the almost wild abandon of his erratic lines have an intense, expressive energy. This powerful style was an effective vehicle for developing his biting social and political commentary.

### 13. James Barry (1741-1806)

Barry was considered the most distinguished history painter of his time. He was born in Cork, Ireland, and was initially self-taught as an artist. In 1763 he moved to Dublin where he was introduced to the philosopher and statesman Edmund Burke who became his mentor and patron. Burke invited Barry to London in 1764 and helped sponsor his studies in Italy from 1766 to 1770. Upon his return he began to exhibit at the Royal Academy and was appointed professor of painting in 1782. He was an active member of the academy until his expulsion in 1799 for his quarrelsome behavior. To advance the cause of history painting in England Barry proposed several vast decorative schemes. His only project to reach completion was executed for the Society of Arts building in the Adelphi, London, where he worked from 1777 to 1783. Barry's teachings in the Royal Academy and his paintings in the Society of Arts

influenced many of the young artists of his day.

## The Angelic Guards, c. 1802

Pen and brown ink with gray wash over pencil; scored for transfer; 27 7/8"x19 3/4"

Engraved: The drawing was etched by Barry in about 1802.

Provenance: unknown

Acquired: 1967 (67.12)

Note: *This drawing was preceded by another preliminary study, now in the British Museum. See William Pressley,* James Barry *(New Haven and London, 1981), p. 252.*

Single-handed and without adequate recompense, Barry undertook the decoration of the walls of the great room in the Society of Arts with his own didactic narrative on *The Progress of Civilization.* The Huntington drawing is related to his wall painting of *Elysium and Tartarus or the State of Final Retribution* which concludes the series. He wrote, "it was my wish to bring together in Elysium, those great and good men of all ages and nations, who were cultivators and benefactors of mankind." Tartarus, by contrast, is inhabited by figures which represent dark, hellish forces. Monumental angelic guards are posed on a rocky barrier separating the earthly paradise of Elysium from the horrific regions of Tartarus. These imposing archangels were singled out for praise and compared to the sublime works of Michelangelo and Raphael, which may have en-

couraged Barry to develop these figures as a self-contained subject for a print.

In the Huntington drawing Barry utilizes bold, emphatic outlines and strong chiaroscuro effects to heighten the dramatic impact of his subject. The physical distortions and contortions add to the sense of dramatic tension. Barry has increased the sense of immediacy by pressing his enormous figures close to the picture plane. These monumental, Michelangelesque figures seem barely contained by the picture space. They exude power and energy.

Barry probably was influenced in the development of this forceful style by the writings of Edmund Burke. In Burke's treatise on aesthetic effects in art, strong chiaroscuro and spatial congestion are associated with the great emotional intensity of sublime themes. Barry has utilized most of these physical characteristics to describe his own sublime subject. When treating a subject of more tender emotions he would alter his linear patterns to evoke the physical properties Burke associated with the beautiful. He would adjust his style for different emotional effects. Barry's linear style and the wide range of his historical and literary subjects were a pervasive influence in late eighteenth-century English art.

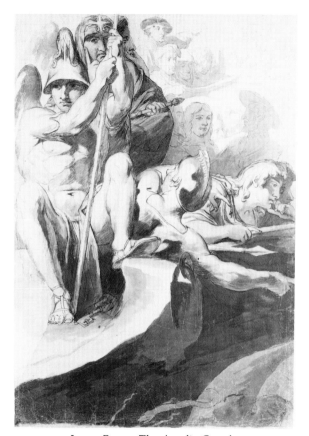

James Barry: *The Angelic Guards*

## 14. **William Blake** (1757-1827)

Today Blake is recognized as a distinguished poet, painter, and book illustrator, but in his own day he had to rely on his work as an engraver to support himself. Born in London, he studied at Shipley's School and was apprenticed to the engraver James Basire. After a brief period in the Royal Academy Schools where he was influenced by Barry's teachings, Blake rejected all further association with the academy. Despite his vehement disagreement with the tenants of the Royal Academy (as promulgated in Reynolds' *Discourses*), Blake held narrative art as the highest goal of art.

### *Satan, Sin, and Death: Satan Comes to the Gates of Hell*, c. 1808

Pen and watercolor, with touches of liquid gold; 19 1/2"x15 7/8"

Signed with Blake's monogram, 'inv./WB' [bottom left] and inscribed [on the back, not by Blake]: drawn for Mr. Butts from whom it passed to Mr. Fuller

Provenance: Thomas Butts; Thomas Butts, Jr.; Mr. Fuller; H. A. J. Munro; R. P. Cuff; Charles De C. Cuff

Acquired: 1916 (000.3)

Note: *Robert Essick suggests that*

*this version of* Satan, Sin, and Death *became detached from the other designs in the Butts series when the group was dispersed at auction in 1868. Ten of the other eleven Butts illustrations are signed "W Blake" and are dated 1808; but it is possible that this design was executed as an independent work at a slightly earlier date, perhaps even before the other version in the Huntington. Blake rarely used the distinctive monogram appearing on this design after 1806. Satan, Sin, and Death is the only design in the series with this monogram, and the only one touched with liquid gold. A lapse of time might also explain the inconsistency of picturing Death without a beard, for he is shown with a long, flowing beard in the tenth and eleventh designs of the Butts series.*

See Robert N. Essick, The Works of William Blake in the Huntington Collection. A Complete Catalog *(San Marino, 1985), pp. 54-56.*

Blake's watercolor illustrates an episode from Milton's *Paradise Lost*, II, 645ff, when Satan encounters Sin and Death at the gates of hell. Sin intercedes between Satan and Death, the specter-like figure, to reveal to Satan that Death is their offspring. This was a particularly popular subject among eighteenth-century English artists, including Hogarth, Fuseli, Barry, Stothard, Gillray, and Martin, perhaps because it was used by Edmund Burke as a paradigm of the sublime in his influential aesthetic treatise.

Blake is known nowadays for his visionary mythology and unique composite art form which interweaves visual and verbal effects. An original and visionary artist, Blake's imagination was his chief source of inspiration. Blake also illustrated other authors, particularly the great English writer John Milton. In his later years he devoted much of his artistic energy to the illustration of Milton's works,

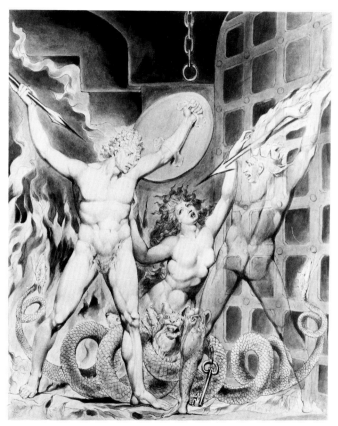

William Blake: *Satan, Sin, and Death*

although none of these projects were published in his own lifetime. He may have been attracted to Milton's texts because of his own very original theories about the fall and redemption of mankind. This watercolor came from his second set of illustrations for *Paradise Lost* which was commissioned by Thomas Butts.

The pen and watercolor technique and the linear style of the Huntington version of *Satan, Sin and Death* links Blake's work to that of several of his contemporaries. Line, particularly emphatic contour line, is his primary vehicle of expression. Blake has sacrificed anatomical accuracy in order to maximize the flow of these taut outlines. The distorted and often mannered physical proportions of his figures add to the expressive weight of the narrative. Blake sought to evoke sublime emotions in his audience by his use of jagged, broken lines, sharp angles, and vivid colors. In doing so he duplicated those physical properties Burke associated with the sublime in his influential treatise. Like several of his fellow artists, Blake adjusted his lines when treating more idyllic narratives to create gently flowing contours complemented by delicate watercolor washes in accord with Burke's description of the beautiful.

## 15. John Flaxman (1755-1826)

Soon after his birth Flaxman moved with his family to London. He received his initial artistic training from his father, a modeler and cast maker, before entering the Royal Academy Schools (1770-75). During his stay in Italy from 1787 until 1794 Flaxman established his reputation as both a sculptor and an illustrator. He gained international acclaim and many imitators after the publication in 1793 of his outline illustrations to Homer. Upon his return to England, he became a member of the Royal Academy and in 1810 was elected professor of sculpture.

*Design for the Shield of Achilles, the portion depicting the siege, ambuscade, and military engagement*, c. 1810

Pen and brown wash over pencil; 8 7/8"x15 1/4"

Provenance: unknown

Acquired: 1965 (65.6.62)

Note: *Robert Wark posits that this design was created as early as October 1810. Related drawings are in the British Museum and in the collection of Christopher Powney. See Robert R. Wark,* Drawings by Flaxman in the Huntington Collection *(San Marino, 1970), p. 77.*

In about 1810 the silversmith firm of Rundell, Bridge and Rundell commissioned from Flaxman a three-dimensional representation of the shield of Achilles as described in the famous passage in the *Iliad* (Book XVIII).

John Flaxman: *Design for the Shield of Achilles*

Flaxman closely followed Homer's description, working from the original Greek text. This drawing represents one section of the continuous story which is depicted in the circular frieze around Flaxman's shield. In this portion Pallas Athena and Ares lead the Greeks into battle. Flaxman worked on this commission from about 1810 until 1818. The silversmiths continued work on the project until at least 1823. Flaxman began with a set of drawings, then sculpted a model. From this several plaster casts were executed, one for the Royal Academy, one for Thomas Lawrence, and one for Flaxman himself. Bronze versions also were cast. Four silver-gilt versions went to George IV, the duke of Northumberland, Lord Lonsdale, and the duke of York. The last is now in the Huntington collection. Flaxman's shield was highly praised by his contemporaries and influenced many subsequent designs for silver plate.

Flaxman and his close friends Blake and Stothard experimented in the 1780s with developing an expressive linear style. Flaxman, however, went further than his friends in exploiting the abstract potential of line. He has eliminated most spatial recession or other illusionistic effects which would interfere with his two-dimensional linear rhythms. Sparse pen lines give great clarity to his designs. His radical simplification of forms and the use of a shallow, frieze-like space concentrates all attention on the long, continuous contours and maximizes their expressive effect. All meaning is focussed on the edges of his forms and is quickly comprehended.

In this drawing Flaxman utilized a pen and wash technique but he often relied on a pure outline which was easily translated into line engraving. Line engravings after Flaxman's designs to Homer, Aeschyles, and Dante had a profound influence on the newly-developing taste for the neoclassical throughout Europe in the late-eighteenth and early-nineteenth century.

### 16. **David Wilkie** (1785-1841)

A Scotsman, born in Cult, Fifeshire, Wilkie studied at the Trustees' Academy in Edinburgh and the Royal Academy Schools in London. He became a full member of the Royal Academy and exhibited there from 1806 until his death. In 1823 he was appointed King's Limner for Scotland and in 1830 Painter in Ordinary to the king. He was knighted in 1836. Wilkie traveled to the Middle East, as well as the continent. He painted a wide range of subjects, including portraits, but was famous for his sentimental, domestic, genre scenes which influenced many of his fellow artists.

*Napoleon and Pope Pius VII at Fontainebleau,* 1828

Watercolor over pencil; 11 1/8"x8 1/4"

Inscribed: Fontainbleau June 9th 1828

Provenance: [?] Sir William Knighton; Sir W. W. Knighton; Jervoise; Mrs. Hart; [?] W. A. H. Martin; Gilbert Davis

Acquired: 1959 (59.55.1453)

Note: *Related drawings are in the British Museum and the Pierpont Morgan Library. The finished oil painting is in the National Gallery of Ireland, Dublin. A leading Wilkie scholar, Professor H. A. D. Miles, director, The Barber Institute of Fine Arts, indicates in a letter that there is no evidence to support earlier claims that an oil sketch was executed prior to the picture in Dublin and served as the basis for an engraving by Robinson. Although Robinson's engraving can no longer be traced, Miles feels it is clear from Wilkie's correspondence that the Robinson engraving was made after the painting, perhaps as a private plate. Miles further suggests that the engraving by Armytage in* The Wilkie Gallery *(London, n.d.) was made from a drawing, possibly the Huntington drawing, which was owned by Knighton and passed to his son, Sir W. W. Knighton.*

This watercolor is a study for the painting *Napoleon and Pius VII at Fontainebleau in 1813* which was exhibited at the Royal Academy in 1836. It was considered by some of Wilkie's contemporaries to be the most important of his historical paintings. It records the dispute between Napoleon and Pius VII over control of papal lands which resulted in Napoleon's removal of the pope to Fontainebleau. In *The Wilkie Gallery* (London, n.d.), the anonymous author declares,

> few subjects could have been better chosen to display the powers of a great painter. The meek

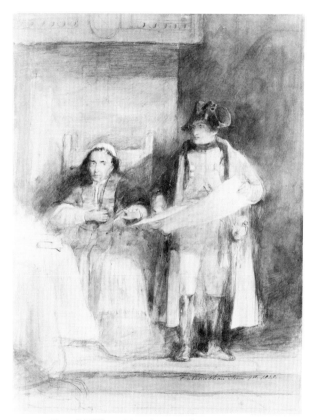

David Wilkie: *Napoleon and Pope Pius VII*

39

yet firm manner of the imprisoned and suffering pontiff, as he refused to sign the document forced upon him by his imperial jailor, finely contrasts with the haughty and almost insulting demeanour of the latter. It is the contest between the two great powers, the spiritual and the military, which then divided between them the empire of Europe.

This subject is characteristic of the type of narrative popularized by Wilkie in the early nineteenth century. *The Wilkie Gallery* author correctly focused on Wilkie's concern with recording the personal interactions of his historical figures. Wilkie has deftly arranged his composition to emphasize the private, psychological nature of this narrative. In composing the Huntington watercolor he worked initially in pencil to establish the forms, then added fluid watercolor washes to block out light and dark relationships and the color composition. These washes duplicate the painterly effects which characterize Wilkie's painting style and enhance the sense of three-dimensional mass and weight.

## 17. **John Martin** (1789-1854)

A painter and book illustrator who specialized in catastrophic subjects, Martin was born in Northumberland and apprenticed first to a coach painter, then to an Italian painter, Boniface Musso. He moved to London in 1806 and from 1811 to 1852 exhibited regularly at various exhibiting societies, including the Royal Academy. Martin found a broad popular market for engravings after his sensational biblical subjects. He also was appointed Historical Painter to Princess Charlotte and Prince Leopold.

### *Biblical Subject*, 1837

> Watercolor heightened with white; 9 5/8"x8 1/2"
>
> Signed and dated: J. Martin 1837
>
> Provenance: Sir Bruce Ingram
>
> Acquired: 1963 (63.52)

This watercolor may relate to Martin's painting of *The Death of Moses* which he exhibited at the Royal Academy in 1838. The painting, which is now untraced, is described by Martin in the Royal Academy catalog as follows:

> Moses having ascended Mount Nebo, to the top of Pisgah, beholds the promised land. The view comprehends the camp of the Israelites, the Dead Sea, the city of Zeboim, the brook Cedron, Bethlehem, the city of Palms, or Jericho, Bethpage, the Mount of Olives, Valley of Jehosaphat, Mount Zion.

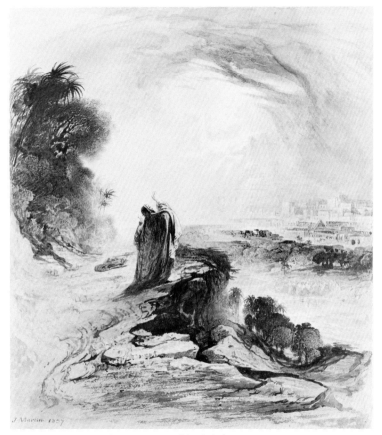

John Martin: *Biblical Subject*

The full light of the setting sun falls directly upon the birthplace of the Saviour, and the site of the Holy City, Mount Moriah. Calvary is faintly indicated beyond, and the great west sea, or Mediterranean, Forms the extreme distance.

The watercolor version seems to include another prophetic episode from the death of Moses which is not noted in the catalog entry. The chariot ascending into the heavens may be an imaginative rendition of the assumption of Moses from the Apocrypha legends.

Although the precise identity of the narrative remains uncertain, Martin's treatment of this scene is characteristic of his work throughout his career. Like many of his fellow artists he sought to evoke sublime, lofty emotions through his art. Martin, however, utilized nature, rather than the human figure, as his chief vehicle of expression. He consistently used vast panoramic views, as in this watercolor, to suggest an immense spatial setting. The awe-inspiring forces of nature, which almost overwhelm the tiny figures, heighten the drama of the narrative. The jumble of fantastic architectural styles in the distance adds a visionary quality to the scene. The dark, reddish-brown tones of the overall color scheme further add to the sense of melodrama. Martin used body color to render the celestial chariot. This opaque white burst of light acts as a dramatic counterpoint to the black, spiky leaves of the palm trees silhouetted against the turbulent sky.

## 18. **Richard Dadd** (1817-1887)

Born at Chatham, Dadd studied at William Dadson's Academy. In 1834 he moved to London and entered the Royal Academy Schools, where he won a medal for life drawing and began exhibiting. He painted portraits and landscapes, but specialized in fairy subjects. While on a trip through the Middle East in 1842, Dadd began to display signs of mental delusion. Upon his return to England his insanity became more pronounced, culminating in the murder of his father. In 1844 Dadd was committed to Bethlem Hospital and later moved to Broadmoor. Although he spent the remainder of his life in these asylums, Dadd was encouraged to continue painting by his physicians who admired and collected his work.

*Dymphna Martyr,* 1851

Watercolor; 14 1/4"x10 1/4"

Titled, signed and dated: Dymphna Martyr Richd. Dadd 1851

Provenance: Gilbert Davis

Acquired: 1959 (59.55.391)

Note: *Patricia Allderidge suggests that Dadd might have become acquainted*

*with the story of Dymphna Martyr when traveling through Belgium in 1842. See Patricia Allderidge,* The Late Richard Dadd *(London, 1974), pp. 83-84.*

Dymphna, the patron saint of the insane, was the daughter of an Irish pagan king who wished to marry her after his wife's death. Dymphna, who had become a Christian, fled with the priest Gerebernus to Gheel in Belgium. The king, however, discovered their whereabouts, had his servants kill the priest, and himself beheaded his daughter. From the thirteenth century on St. Dymphna was invoked as a cure for insanity. Gheel, where she was buried, became a center for care of the mentally disturbed.

When Dadd created this watercolor in 1851 his own mental problems would have endowed this story with a special significance. It is the first known watercolor he executed in Bethlem Hospital. Dadd's fascination with bizarre subjects from literature and history, however, long pre-dates his Bethlem period. It also is an interest he shared with many of his contemporaries. Similarly, there are aspects of his style which link his work to that of his fellow artists. The careful, almost obsessive attention to detail in the Huntington watercolor can be seen in the contemporary works of the Pre-Raphaelites. This excessive attention to detail produces intense expressive effects. Although the individual details in Dadd's *Dympna Martyr* are based on naturalistic observation, there is an other-worldly cumulative effect. The watercolor has a highly focused clarity, almost hallucinatory in effect. The Huntington

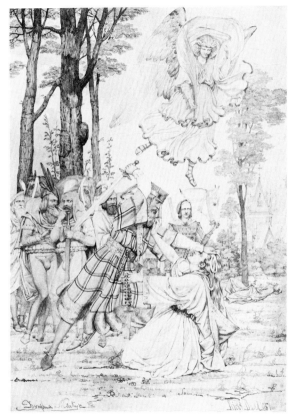

Richard Dadd: *Dymphna Martyr*

43

watercolor also displays Dadd's peculiar, and very effective, use of a violent subject matter and a delicate, clear pastel color scheme. This incongruous combination produces the jarring, often disturbing effects which characterize Dadd's works.

## 19. **William Holman Hunt** (1827-1910)

Hunt, a painter and book illustrator, was born in London. He began his artistic training with a portrait painter before studying at the British Museum, National Gallery, and the Royal Academy Schools. In 1848 he was one of the principal founder members, along with Millais and Rossetti, of the Pre-Raphaelite Brotherhood. Throughout his life Hunt made trips to the Continent and the Middle East, particularly the Holy Land. He gained tremendous popular success with his religious painting *Light of the World* (1851).

*Will-o'-the-Wisp*, c. 1861

> Pen and monochrome wash with traces of pencil; 4 1/8"x5 1/4"
>
> Engraved: The drawing was engraved on wood by H. Harral in reverse and served as frontispiece

to Margaret Gatty's *Parables from Nature*, first series (London, 1861).

Provenance: Mrs. E. Burt by direct descent from the artist

Acquired: 1970 (70.104)

Note: *Judith Bronkhurst, who is compiling a catalog of Hunt's works, indicates that she knows of no other studies for* Will-o'-the-Wisp; *thus, the Huntington drawing is probably the black and white illustration for this work which was exhibited at the Royal Watercolour Society, Winter 1886-87 (no.226).*

This drawing is one of two illustrations Hunt provided for Margaret Gatty's *Parables from Nature*, which sold for one shilling when published in 1861. It is an illustration for "The Light of Truth." In this story the phantom Will-o'-the-Wisp uses a compelling light, which is a friendly lamp to the wise, to lure headstrong fools to a miserable end. One of the victims, a beautiful girl, who is unmindful of the moral laws which should guide her, recklessly follows the light into a swamp. The drawing illustrates the moment, when "in wild despair," she plunges into a black morass. This didactic narrative is indicative of the general shift to more pious subject matter in the Victorian age. Hunt's work is differentiated, however, from most Victorian illustration by his charged, emotional interpretation of the moral and religious symbolism.

During the middle of the nineteenth century, particularly the 1860s, a wood engraving technique flourished in the

William Holman Hunt: *Will-o'-the-Wisp*

innumerable illustrations to the new periodicals and publications aimed at the large reading audience. Some of the designs, such as this one by Hunt, were masterpieces of this emphatic black and white style. Hunt has executed this drawing in a manner which could easily be adapted to wood engraving. He has utilized bold contour outlines to accommodate the wood engraving technique. His freely applied, unmodulated washes would reproduce as flat areas of dark tone. The print after this prepratory drawing reads as a bold black and white design. His evocative, chiaroscuro effects also enhanced the sense of mystery in this brooding, nocturnal scene.

## 20. **Richard Doyle** (1824-1883)

Born in London, Doyle received his artistic education from his father, John Doyle, a social and political caricaturist. Several of Richard's many brothers and sisters also turned to art. By the age of nineteen Richard was a regular contributor to *Punch*. He quickly became a successful comic artist and book illustrator. After 1846 he became increasingly well known for his charming fairy subjects.

### *The Altar Cup of Aagerup*

Pen and watercolor; 12″x18″

Provenance: Gilbert Davis

Acquired: 1959 (59.55.446)

Note: *The following related works have been located: a pencil drawing and a watercolor in the Fitzwilliam Museum, Cambridge; a painting dated 1883 in the Cecil Higgins Art Gallery, Bedford; a pen and wash drawing sold at Sotheby's, London, July 26-27, 1984 (lot 674); and a watercolor at Christies's, illustrated in Rodney Engen,* Richard Doyle *(Stroud, Glos., 1984), p. 151. Engen (pp. 199-202) lists several versions of* The Altar Cup of Aagerup *which were exhibited just before and after Doyle's death.*

This watercolor probably represents *The Altar Cup of Aagerup*. The obscure Danish legend of Aagerup is described in Thomas Keightley's influential book, *The Fairy Mythology*, first published in 1827:

> When it was drawing near day he [the farmer] returned them [the Trolls] his very best thanks for his entertainment, and mounted his horse to return home to Aagerup. They now gave him an invitation to come again on New-year's night, as they were then to have great festivity; and a maiden who held a gold cup in her hand invited him to drink the stirrup-cup. He took the cup; but, as he had some suspicion of them, he, while he made as if he was raising the cup to his mouth, threw the drink out over his shoulder, so that it fell on the horse's back, and it immediately singed off all the hair. He then clapped spurs to his horse's sides,

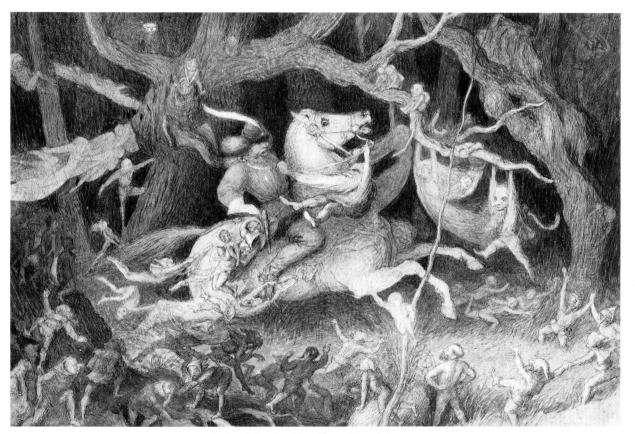

Richard Doyle: *The Altar Cup of Aagerup*

and rode away with the cup in his hand over a plowed field.

The Trolls instantly gave chase all in a body; but being hard set to get over the deep furrows, they shouted out. . . . the Trolls now gained on him every minute. In his distress he prayed unto God, and he made a vow that if he should be delivered he would bestow the cup on the church. . . .

Although several artists in the late-eighteenth and early-nineteenth century dabbled in fantasy art it attained a widespread popularity in the Victorian era that has never before nor since been surpassed. Fairy tales and folk legends were a source of fascination and inspiration for several artists during this period. Doyle's drawings of fairies, trolls and other supernatural creatures are some of the most imaginative evocations of this Victorian fantasyland. His fairy subjects range from playful, delightful flights of fancy to more frightening narratives, such as this story.

Doyle produced fewer designs for illustration toward the end of his life. Instead his energies were devoted to creating finished watercolors, such as *The Altar Cup of Aagerup*, for exhibition. With this purpose in mind, Doyle, like many contemporary watercolorists, built up dense layers of watercolor washes to mimic the rich colors of oil painting. He utilized several standard devices to suggest a fantasy world, such as the juxtaposition of the tiny, small-scale trolls with the full-scale figures of the horse, rider, and setting. In several versions of *The Altar Cup of Aagerup* Doyle set this chase scene in the plowed field described in Keightley's text. In others, such as the Huntington watercolor, he chose a more evocative forest setting. The twisted, knotted limbs of the background trees heighten the eerie, nightmarish feeling of the scene.

### 21. **John Everett Millais** (1829-1896)

Millais was born in Southampton, raised in Jersey and moved to London in 1838. He studied at Henry Sass's Academy and the Royal Academy Schools. Millais was a founder member of the Pre-Raphaelite Brotherhood. He also became a full member of the Royal Academy and was elected president just before his death. He attained great wealth in his later years and was created a baronet in 1883.

*Study for "The North-West Passage,"* 1874

Pencil, red chalks and gray wash, heightened with white; 6 7/8"x7 3/4"

Signed with monogram and dated [lower left]: J M [monogram] 1874; [on mount] D27511

Provenance: Edward Seago

John Everett Millais: *Study for the Northwest Passage*

49

Note: *Malcolm Warner, who is preparing a publication on Millais, has compiled a list of seven sketches, five of which can now be traced, which are associated with* The North-West Passage. *He places the Huntington drawing fourth in the sequence of five known studies.*

This drawing is a study for the oil painting *The North-West Passage*, now in the Tate Gallery, which was exhibited at the Royal Academy in 1874 with the quotation, "It might be done, and England should do it." The engraving made in 1881 by A. Mongin after this painting sold widely and won Millais great popularity.

Millais' son, John Guille Millais, described the painting as

> perhaps the most popular of all Millais' paintings at the time, not only for its intrinsic merit, but as an expression more eloquent than words of the manly enterprise of the nation and the common desire that to England should fall the honour of laying bare the hidden mystery of the North. . . . the brave old seadog . . . [sits] in deep thought . . . By his side is outspread a map of the northern regions; and with her hands resting on his, his daughter sits at his feet, reading what we may take to be the record of previous efforts to reach the Pole. He is at home now—this ancient mariner, stranded on the sands of life, like the hulk of an old ship that has done its duty—but as he listens to these deeds of daring, the old fire burns within him, and in every lineament of face and figure we see how deeply he is moved . . . (*The Life and Letters of Sir John Everett Millais* [New York, 1909], v. II, pp. 48-52).

Millais' Pre-Raphaelite concern with truth to nature continued in his later works. *The North-West Passage* is based on careful studies from models, all of whom are identified by Millais' son. Captain Edward John Trelawny, a friend of Byron and Shelley, served as the model for the old sailor. In his preliminary drawings Millais concentrated on working out the narrative details. He made several further adjustments in the composition after the Huntington drawing. In the painting the features of the sailor have been modified by the addition of a beard and more weather-beaten features. His expression, which has been altered to a grimace, and his clenched left hand are further indications of his brooding thoughts. This work is a good example of the type of anecdotal narrative painting which flourished in the Victorian period. It is an everyday event filled with touching emotions that are meant to appeal directly to a wide audience.

To make his narrative as convincing as possible, Millais has carefully recorded details of contemporary costumes and settings. In his earlier Pre-Raphaelite drawings these details were rendered with meticulous care. Millais developed a greater breadth of handling in his later works such as this drawing. He also was more interested in

developing the three-dimensional aspects of his design by using parallel lines for shading and body color to indicate highlights, thus adding mass and bulk to his figures. These illusionistic effects further enhance the sense of a scene closely observed.

## 22. Walter Crane (1845-1915)

Crane was a versatile artist who executed designs for magazines, children's books, wall paper, textiles, tapestries, history painting, landscape painting, and much else. He was born in Liverpool, the son of a portraitist. In 1857 he moved to London and was apprenticed to an engraver. By 1867 he began producing illustrations for the engravers and publishers, the Dalziel brothers. In the 1870s Crane became associated with William Morris' socialist causes and the Arts and Crafts movement. Crane's views had a widespread impact on the arts because of his influential role as a teacher at various institutions throughout England. He made frequent trips abroad, visiting the United States in 1891.

### *The Goose Girl*, c. 1882

Pen and black ink; sheet size 12"x7 5/8", image

size 8 5/8"x5 1/4"

Signed with rebus; inscribed: [top] GOOSE GIRL [bottom center] 'O WIND, BLOW CONRAD'S HAT AWAY, / AND MAKE HIM FOLLOW AS IT FLIES,/WHILE I WITH MY GOLD HAIR WILL PLAY/AND BIND IT UP IN SEEMLY WISE.'

Engraved: The drawing was engraved by Swain for *The Household Stories of the Brothers Grimm* (London, 1882).

Provenance: J. W. Freshfield

Acquired: 1969 (69.50)

Note: *A related watercolor appeared at Sotheby's Belgravia sale, 23 March 1981, Lot 48: A Goose Girl, signed with monogram, 17"x15 3/4". A tapestry, 7'10"x6', after this design was woven in 1881 at the works of Morris and Co. at Merton Abbey and bought by a Mr. Pope of Cleveland. The cartoon for the tapestry, 96 1/2"x72 1/2", signed and dated MDCCLXXX, is now in the Victoria and Albert Museum, London.*

Literature written and illustrated exclusively for children began as a trickle in the eighteenth century and developed into a flood by the end of the nineteenth century. Crane was one of the most successful and influential artists to execute illustrations, such as the Huntington drawing, for the edification and entertainment of this new audience. The story of *The Goose Girl*, which was translated by Crane's sister, is filled with strange events and magical creatures, including a talking horse, which would appeal to a child's

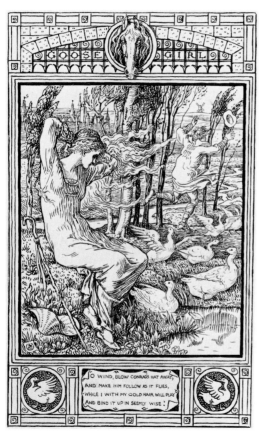

Walter Crane: *The Goose Girl*

imagination. This tale concerns a king's daughter who is bewitched and made into a goose girl. While in this guise she is bothered by a goose boy named Conrad. To rid herself of Conrad she calls up a wind to blow his hat away. Eventually the princess' true identity is revealed. Crane wrote that this design:

> was seen at the time by my friend, the late William Morris, when I was at work in my studio one day. He called to ask me to do him a design capable of being worked in arras tapestry, which he was at that time practically engaged in reviving. He saw this design of the Goose Girl, and taking a fancy to it, asked me to reproduce it as a large coloured cartoon, 8 feet by 6 feet, which I accordingly did; and it was duly worked out by him and his assistants as a tapestry . . . It therefore has a dual existence as a black-and-white book illustration and also a tapestry. [*The Art Journal*, 1899, pp. 7-8.]

Crane, who was committed to the revival of craftmanship during this age of rapid industrialization, set out to produce designs which would be aesthetically pleasing even when mass produced. Prints from his drawings were executed in some cases from photographs after the preliminary designs. This may explain Crane's practice of covering mistakes with touches of white, as in the Huntington drawing, which would not register in a photograph.

In developing a distinctive style which could be effectively reproduced in color prints, he was influenced by the bold outlines, flat patterns, and clear, bright colors of Japanese prints. In this drawing his precise, cursive pen lines create an elegant decorative design. In a manner reminiscent of medieval illuminiation Crane has integrated the caption and ornamental border into his overall design. His full-page illustration acts as elegant embellishment, in this case serving as a delightful counterpoint to the stern morality of the story.